Adult Coloring Book

Ocean Animal Patterns

Blue Star Coloring Books is in San Antonio, TX and P⸱

Teamwork makes the dream work: This book was d⸱
designed by Peter, written by Gabe and published⸱
belongs to Blue Star as of 2015. We reserve all of ⸱

Printed in the United States of America.

We Love What You Create

And We Want to Shout It From the Rooftops

@bluestarcoloring

facebook.com/
bluestarcoloring

@bluestarcolor

bluestarcoloring.com

Show Us
Your Art

We'll Show
The World

We'll never be perfect, but that won't stop us from trying. Your feedback makes us a better company. Send ideas, criticism, compliments or anything else you think we should hear to suggestions@bluestarcoloring.com.

Oh, and if you don't love this coloring book, we'll refund your money immediately. No questions asked. Just e-mail us at guarantee@bluestarcoloring.com.

How to Use This Book

 Break out your crayons or colored pencils.

 Turn off your phone, tablet, computer, whatever.

 Find your favorite page in the book. That is the beginning.

 Start coloring.

 If you notice at any point that you are forgetting your worries, daydreaming freely or feeling more creative, curious, excitable, delighted, relaxed or any combination thereof, take a deep breath and enjoy it. Remind yourself that coloring, like dancing or falling in love, does not have a point. It is the point.

 When you don't feel like it anymore, stop.

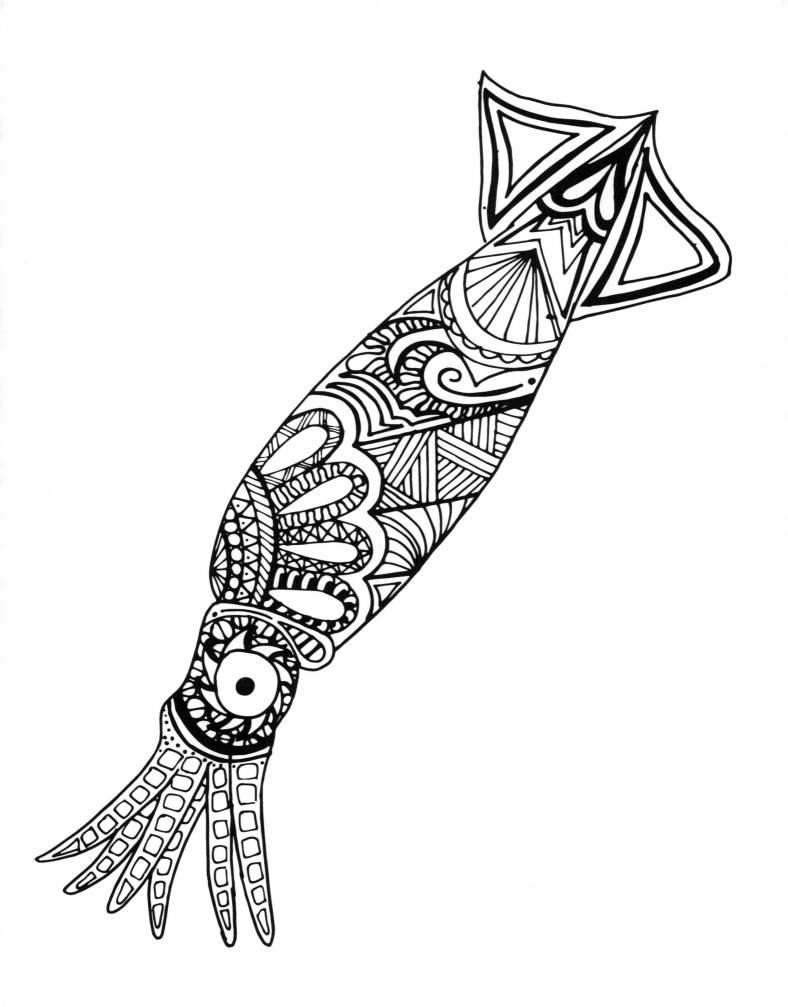

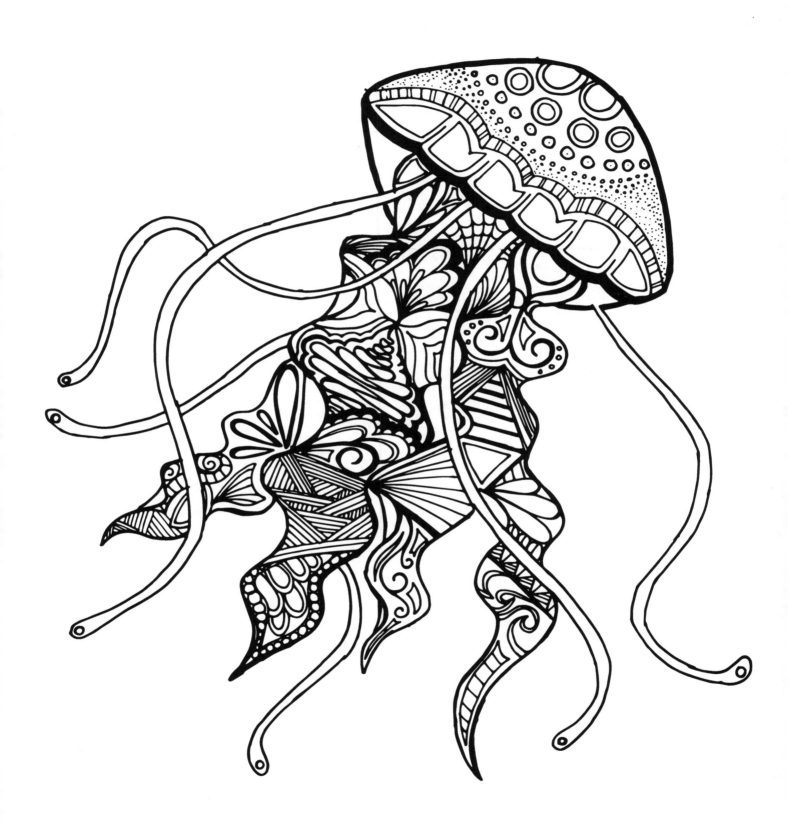

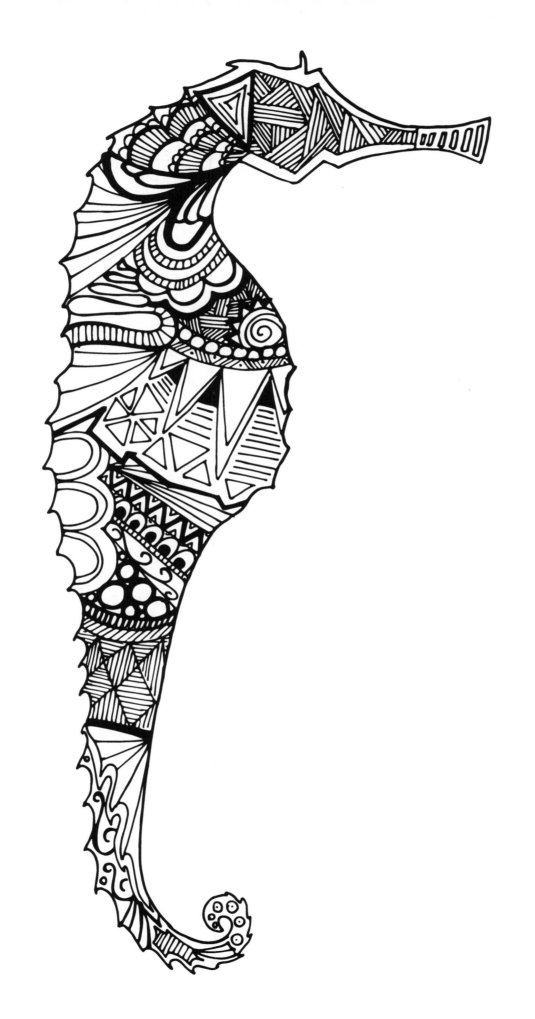

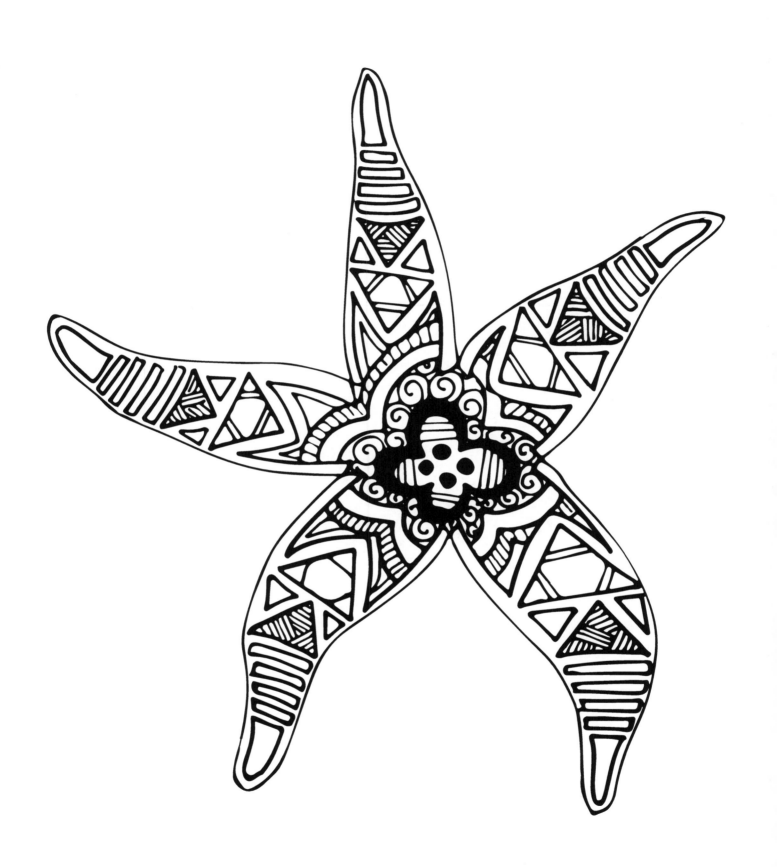

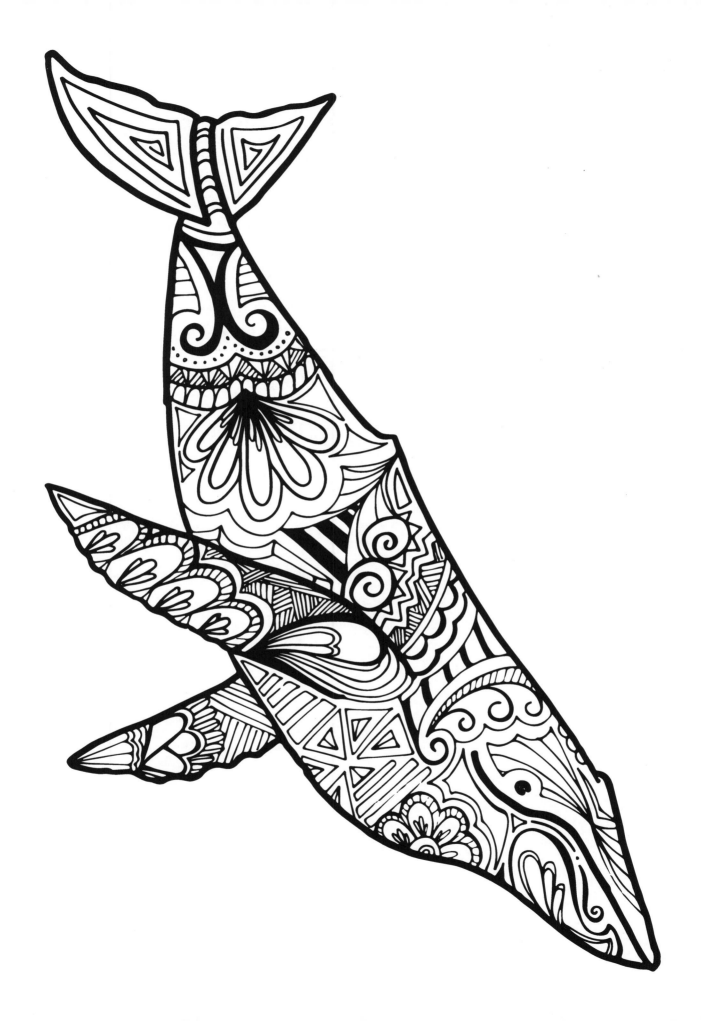

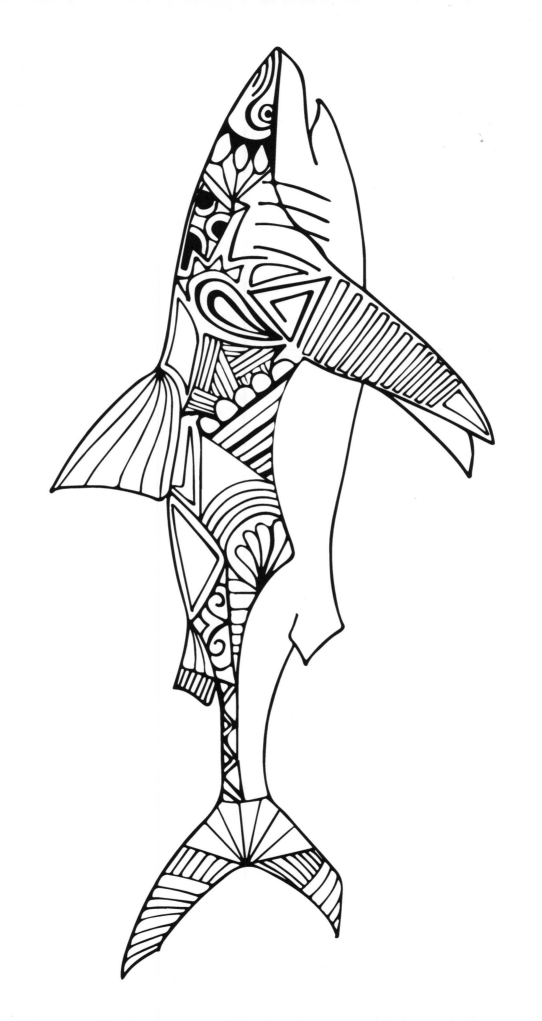

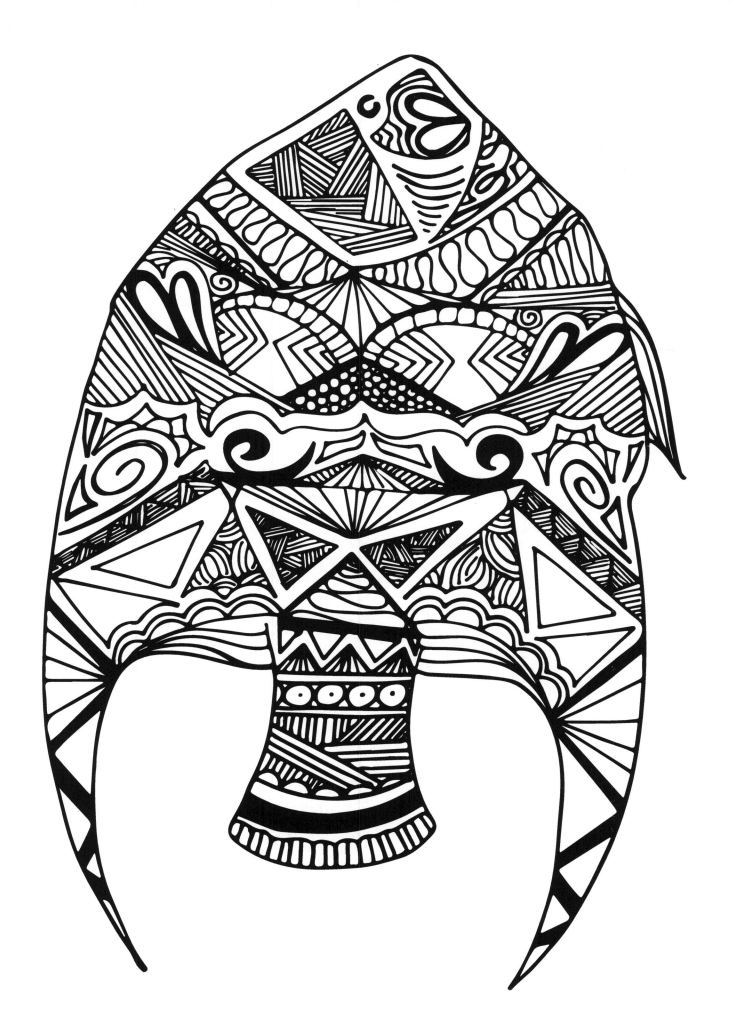

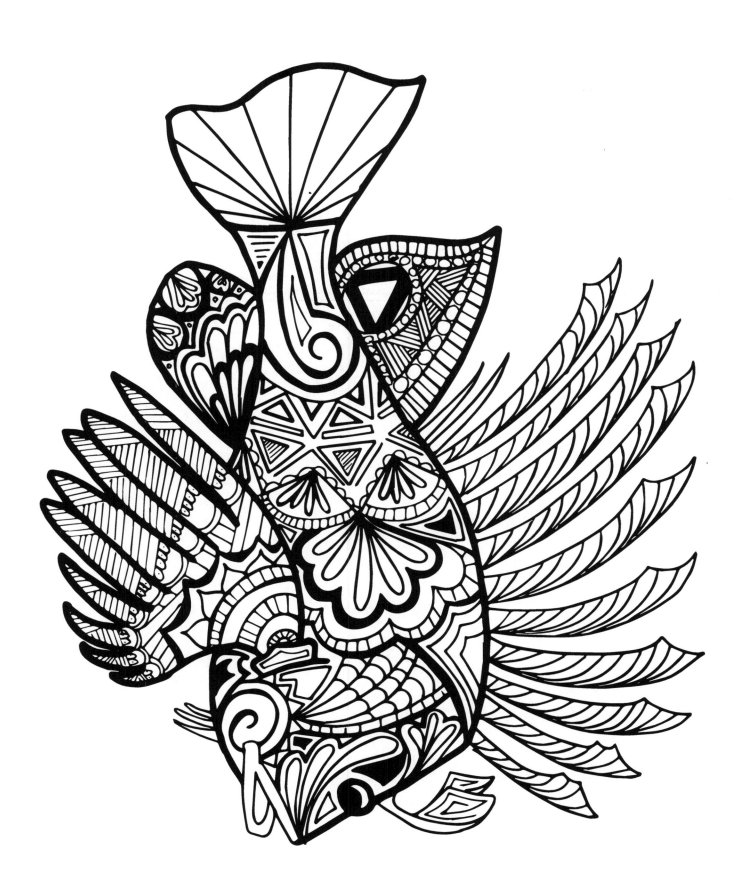

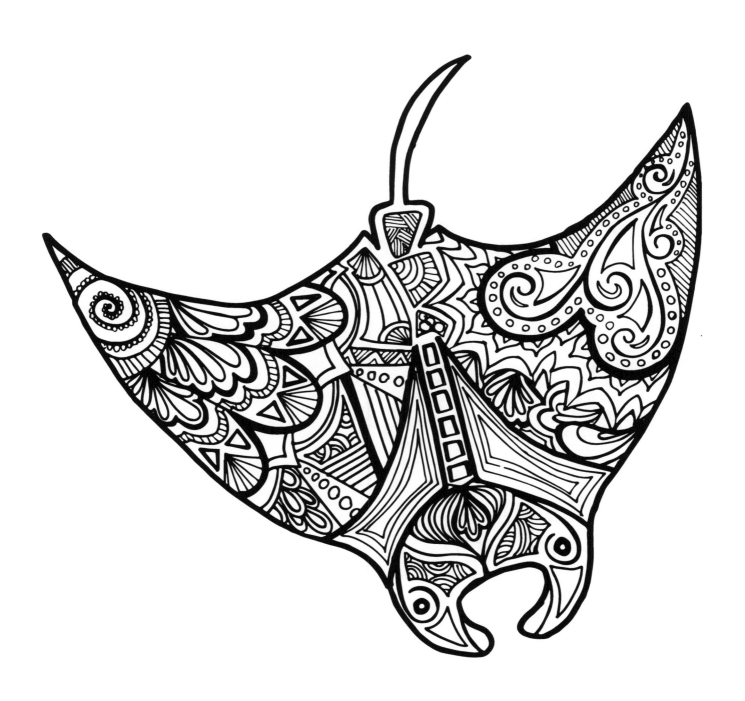

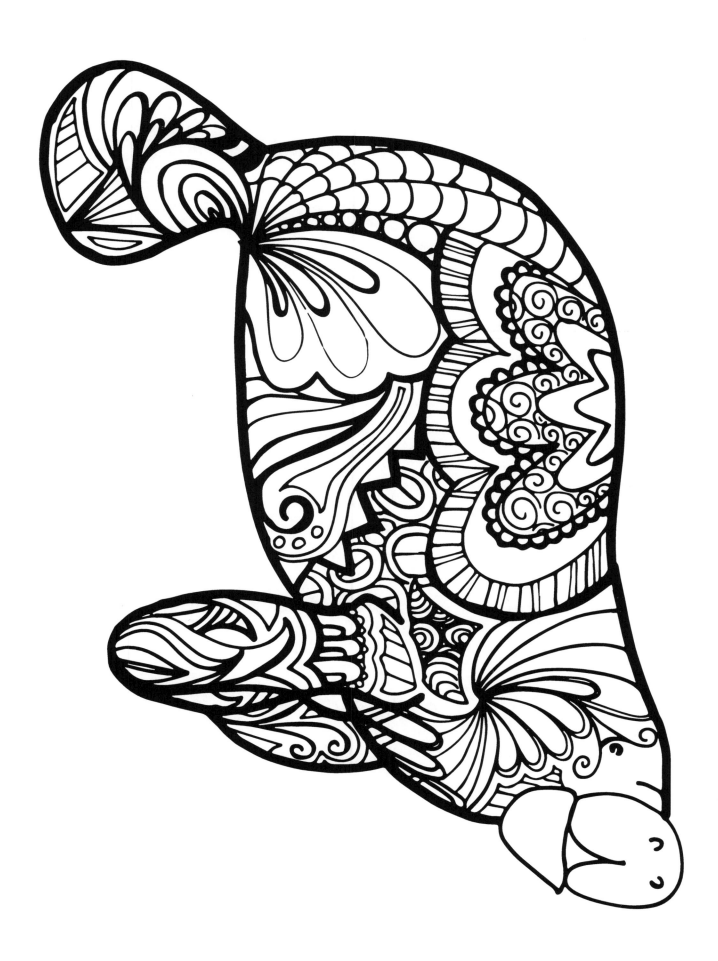

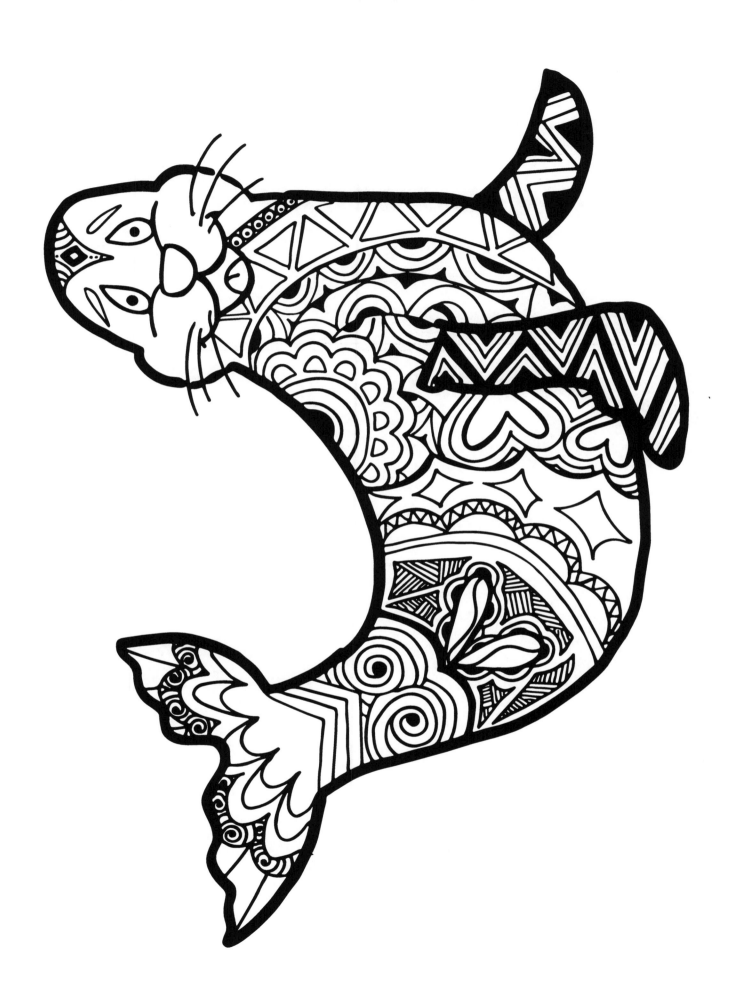

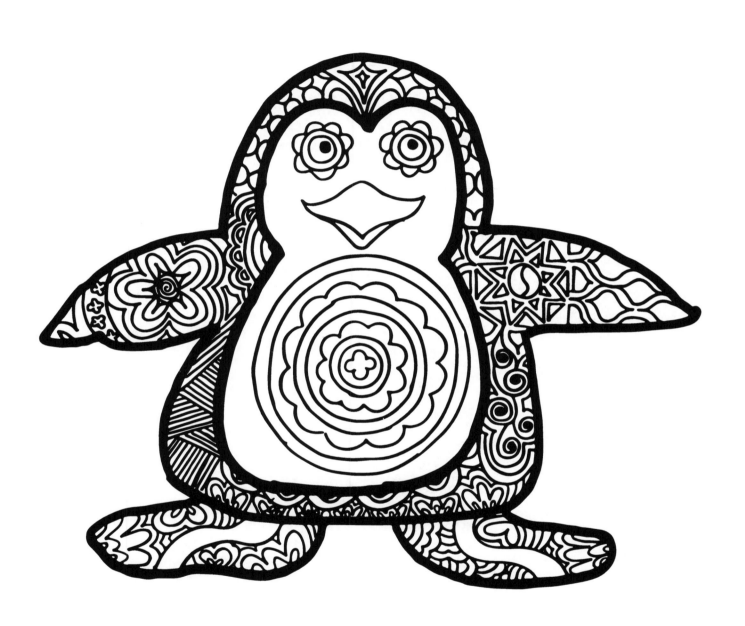

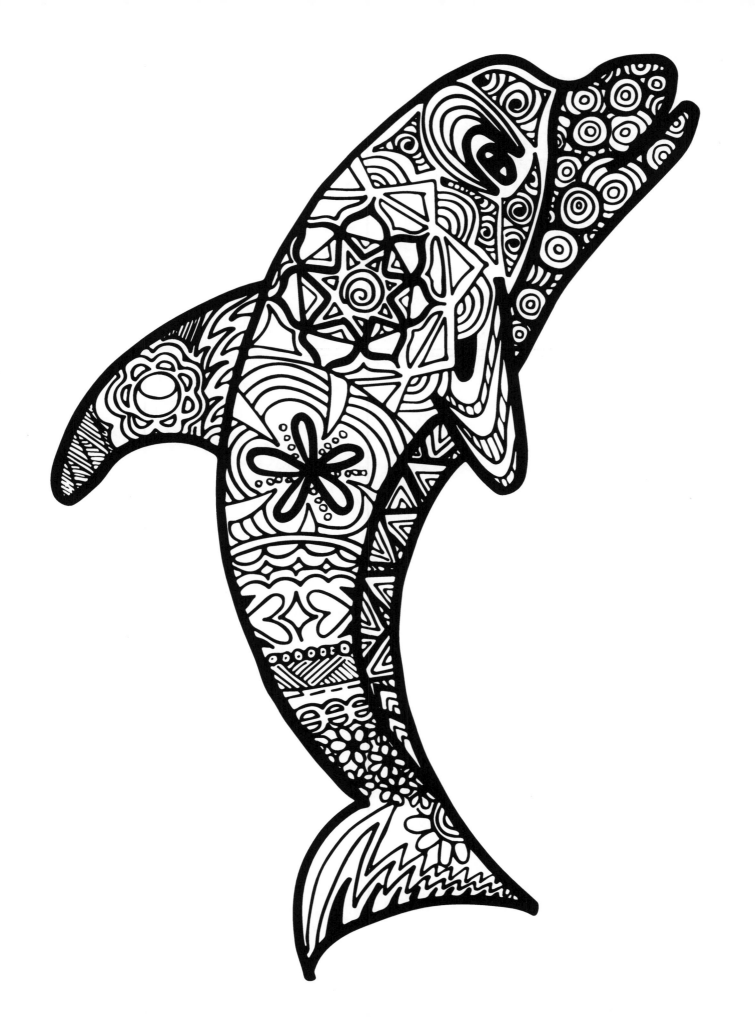

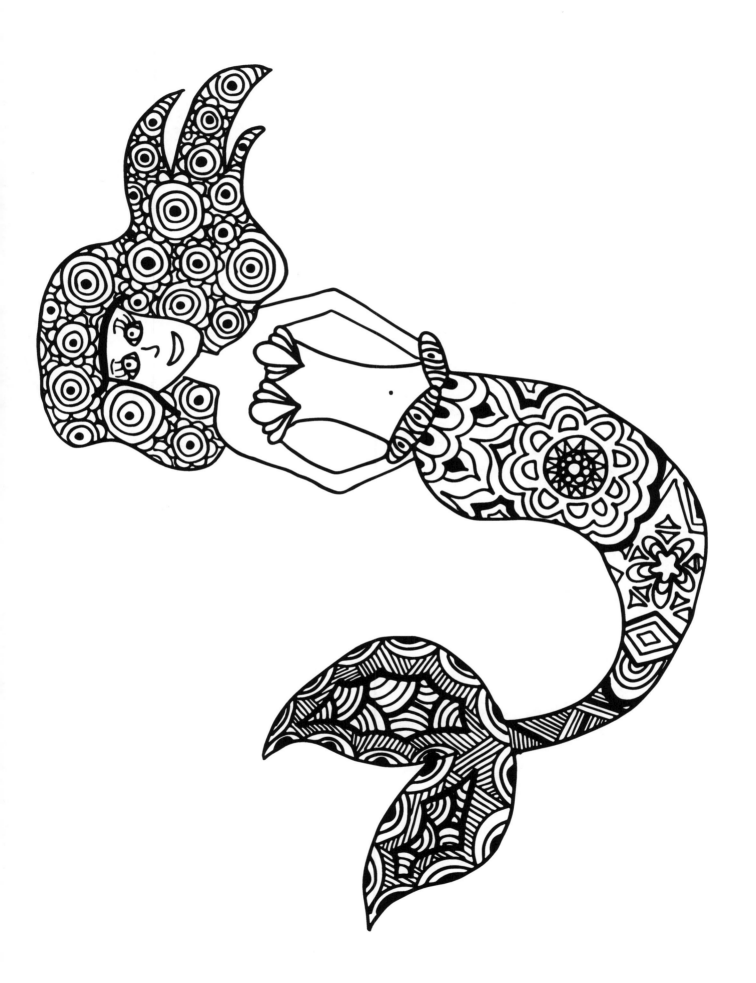

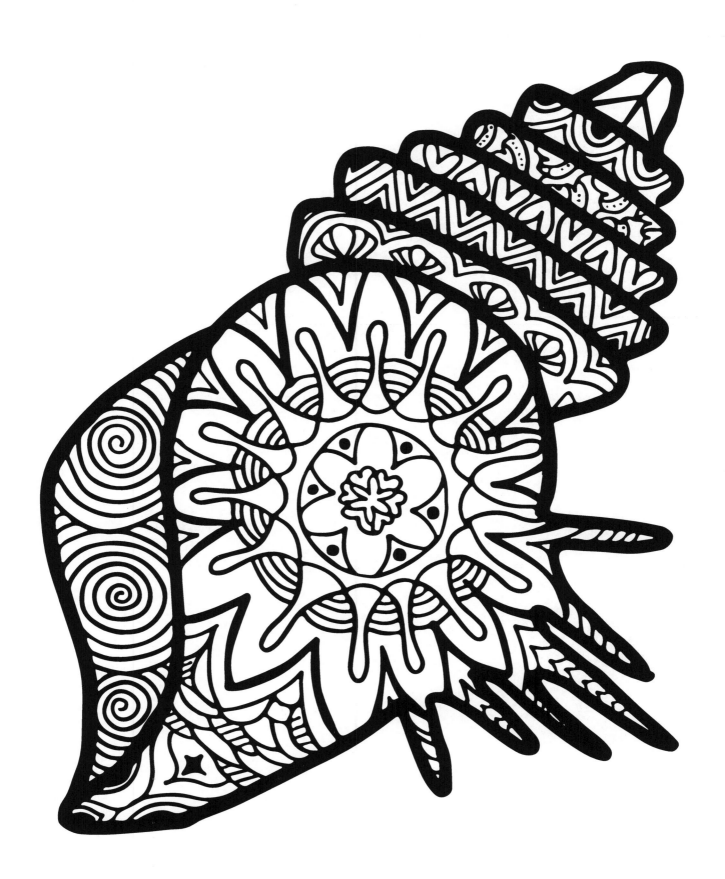

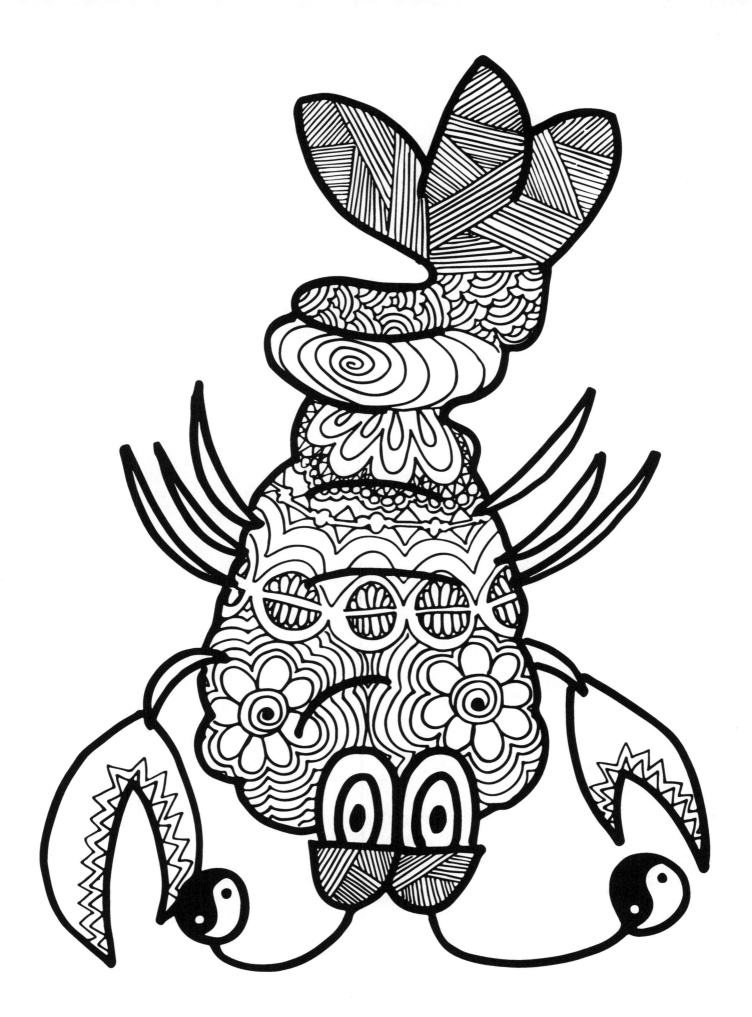

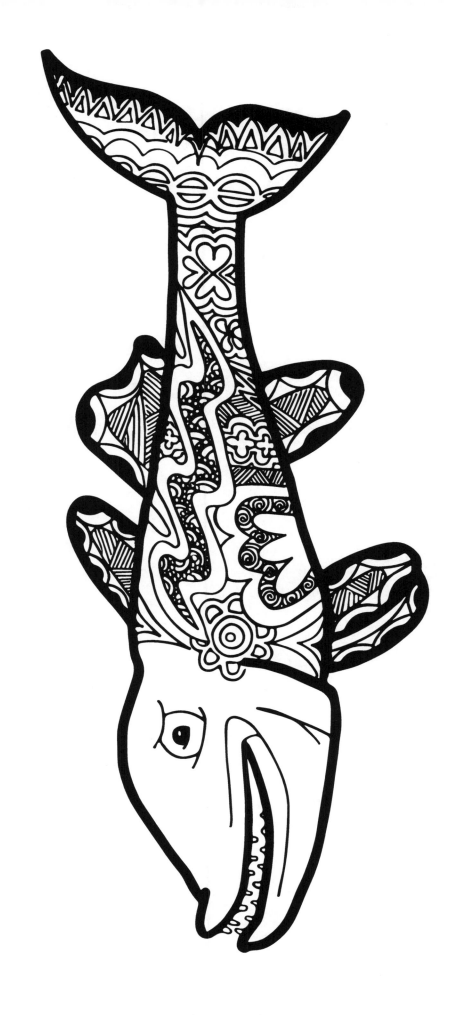

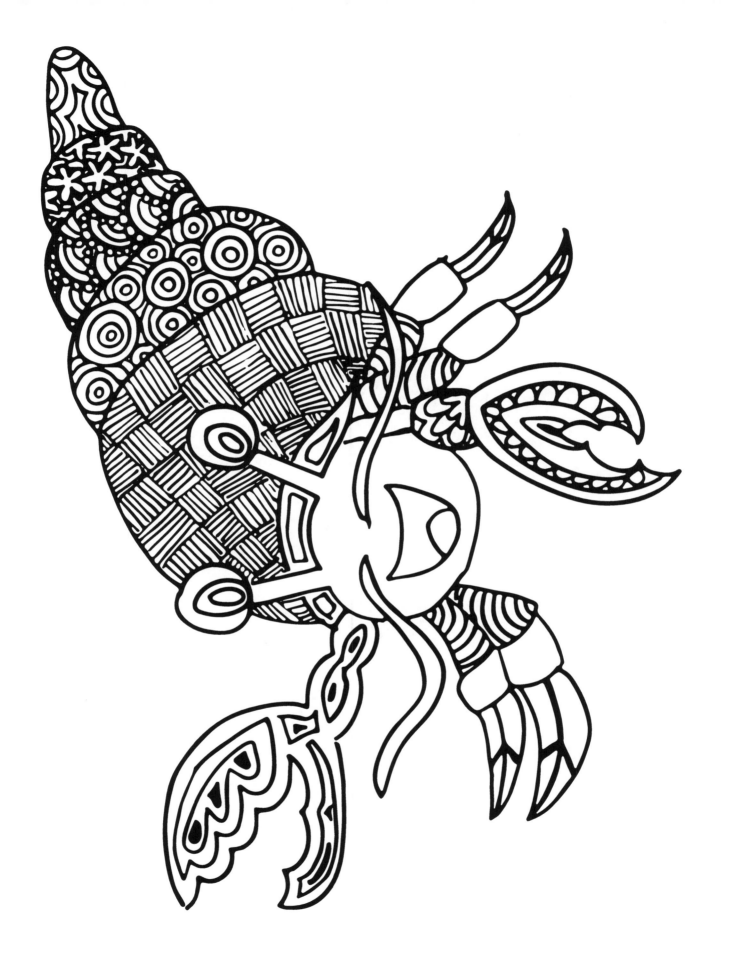

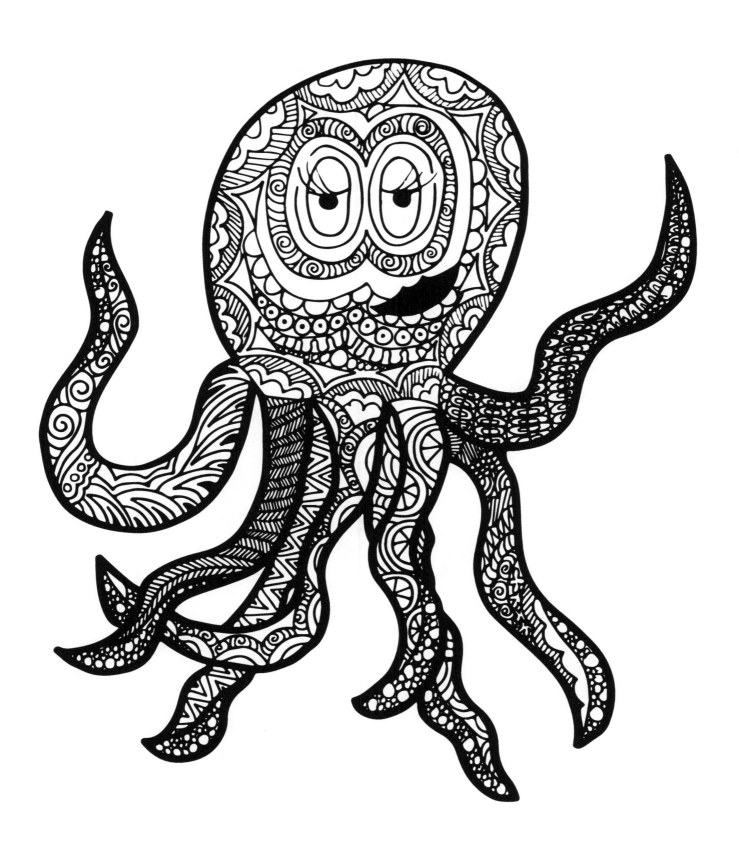

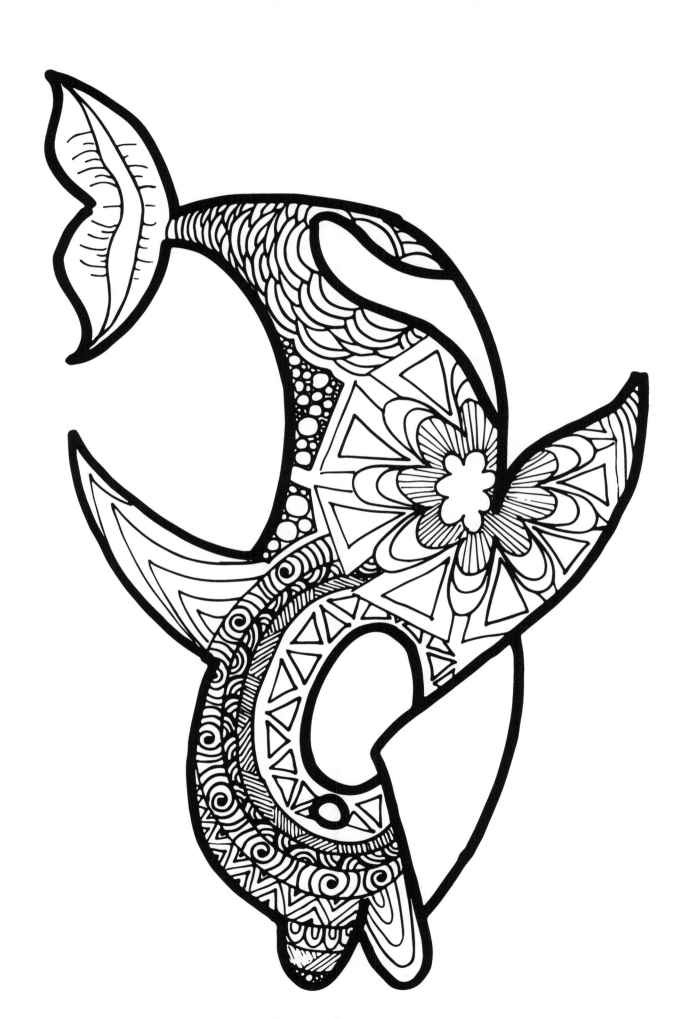

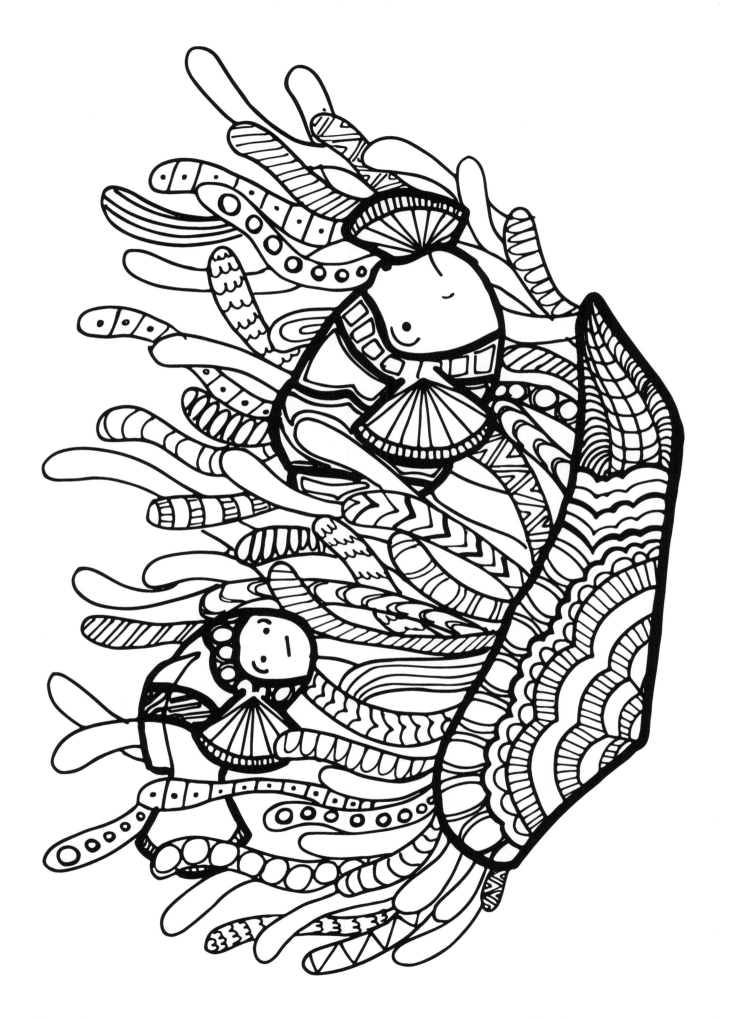

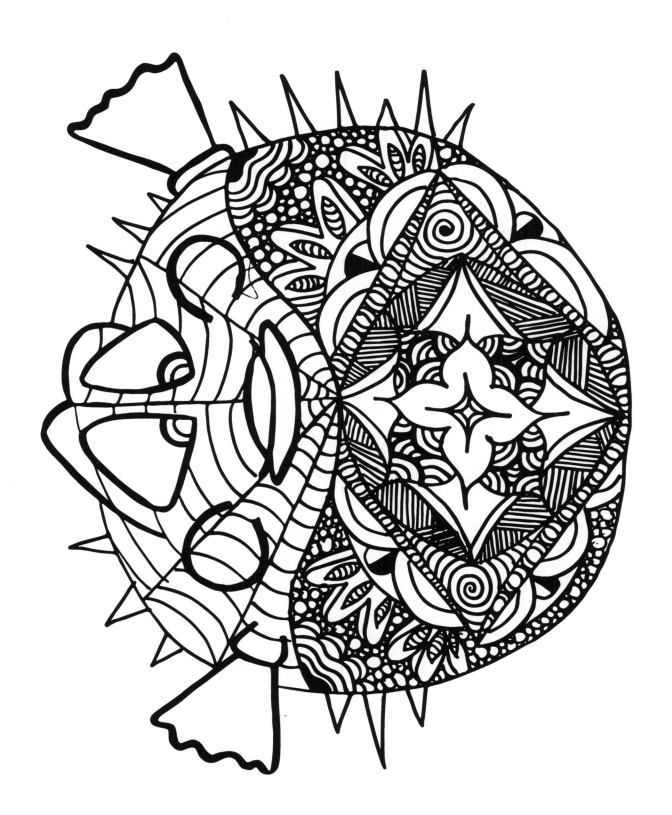

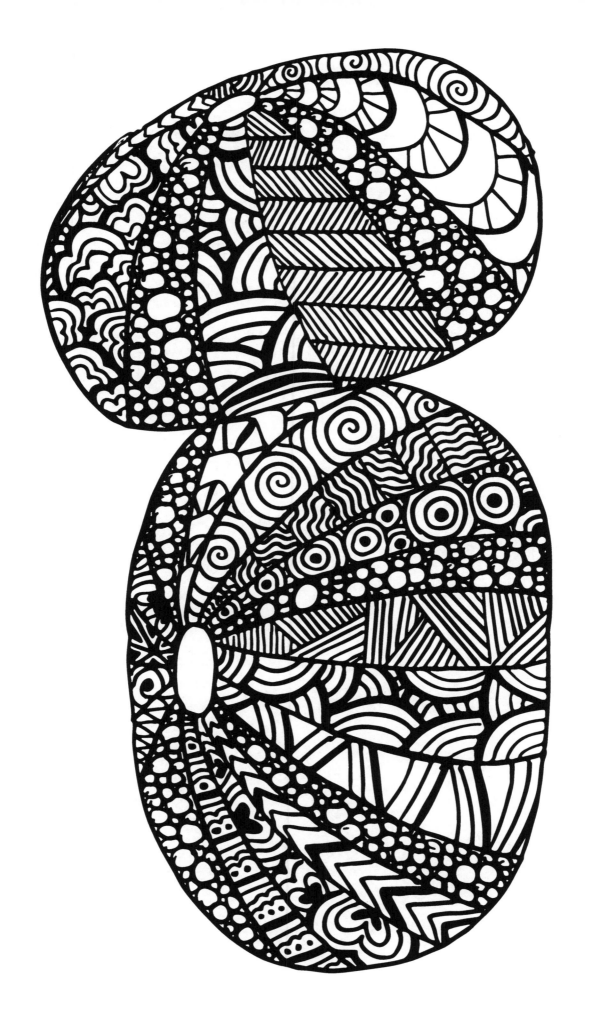

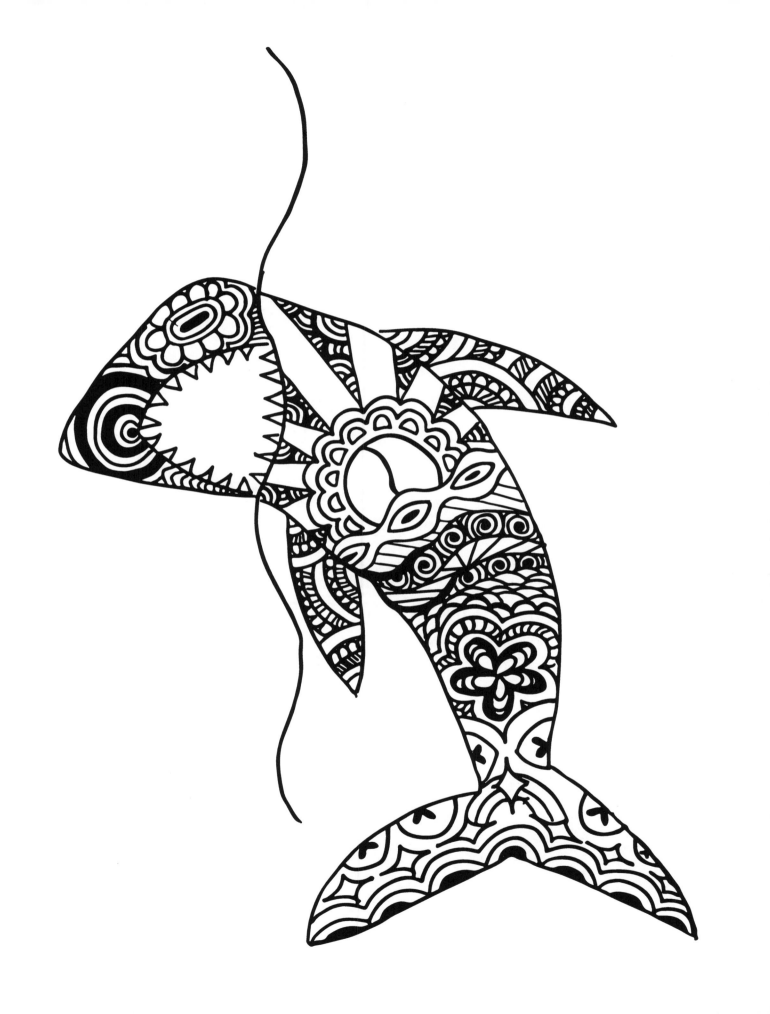

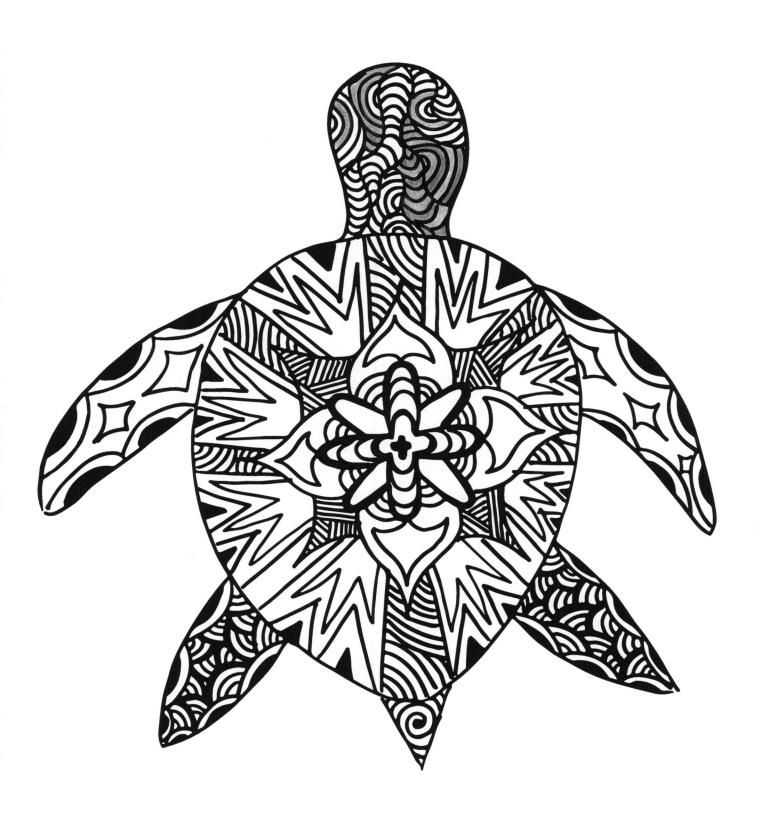

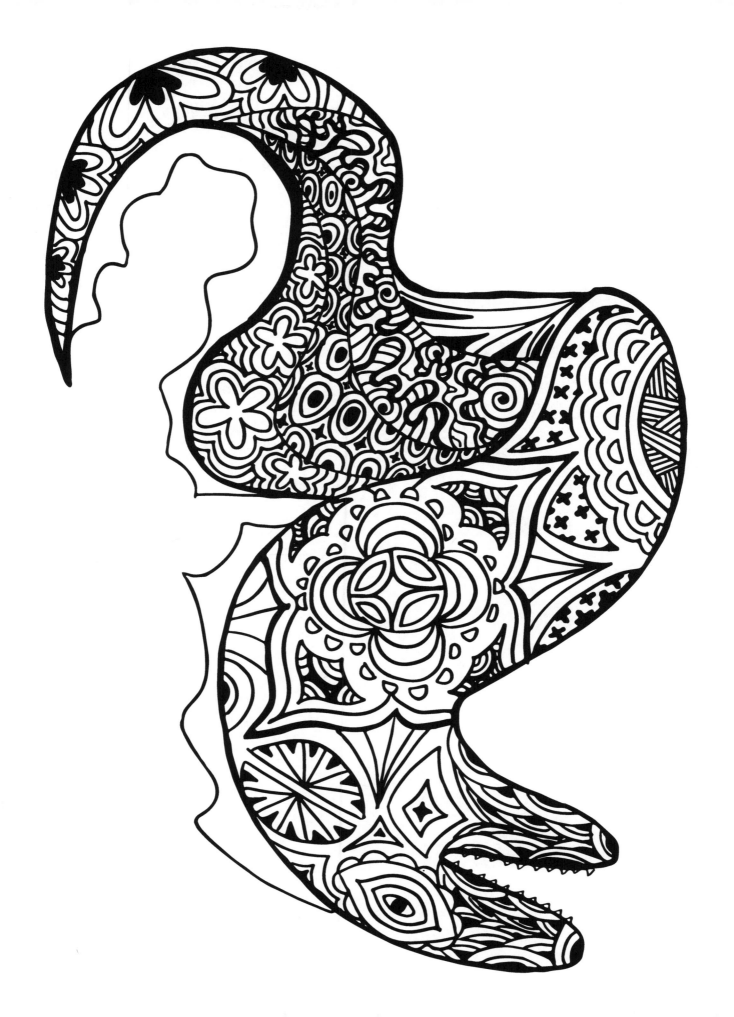

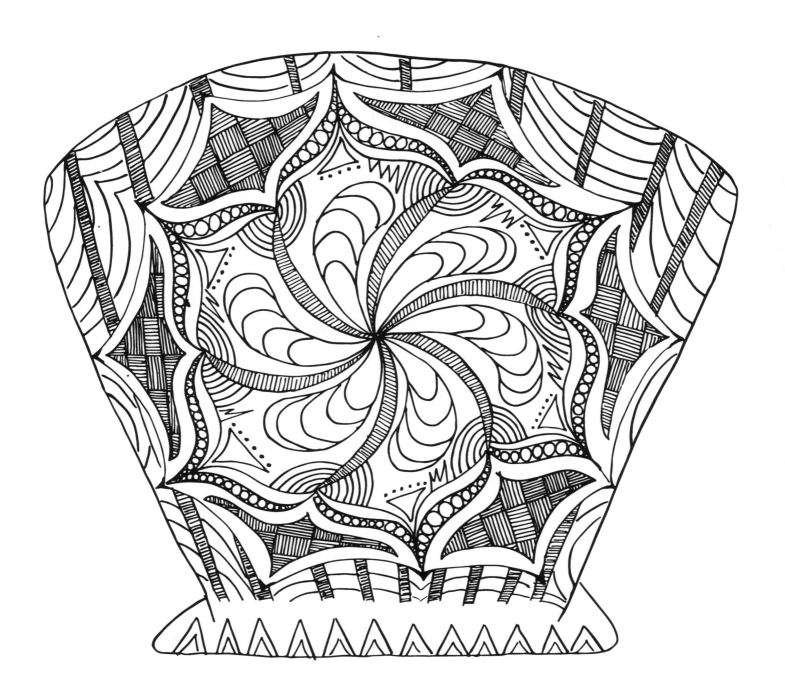

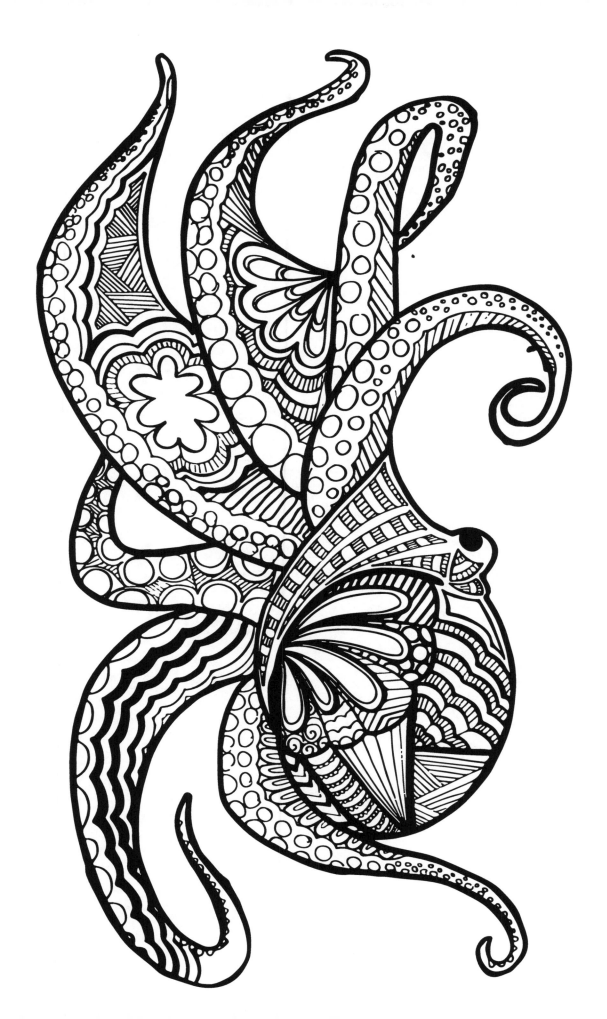

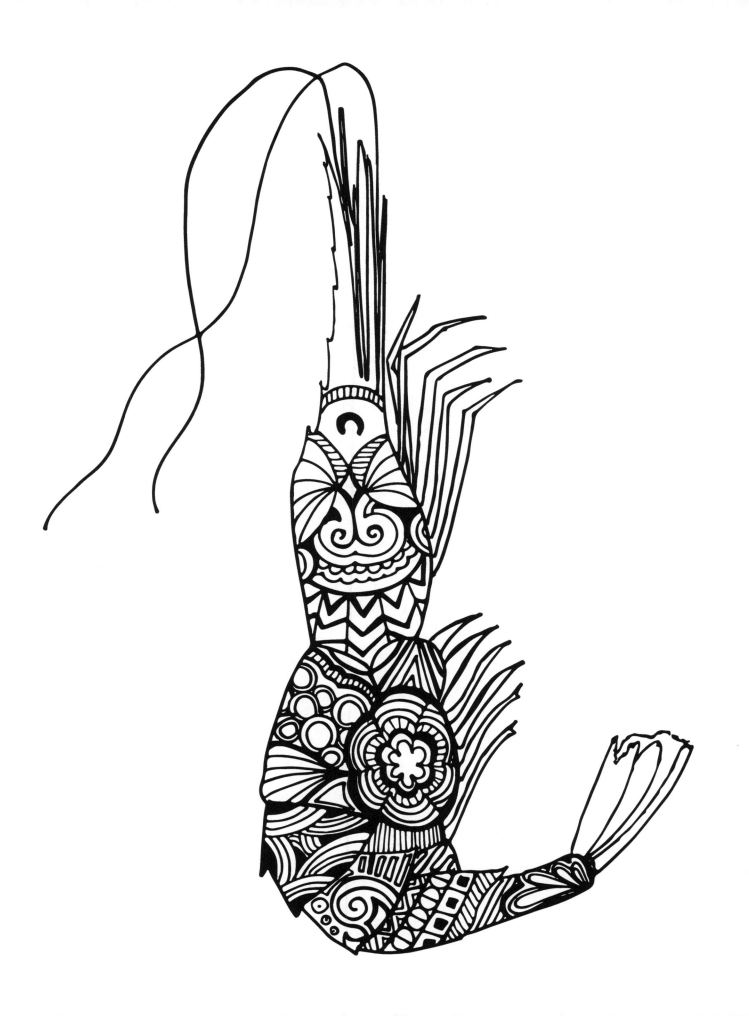

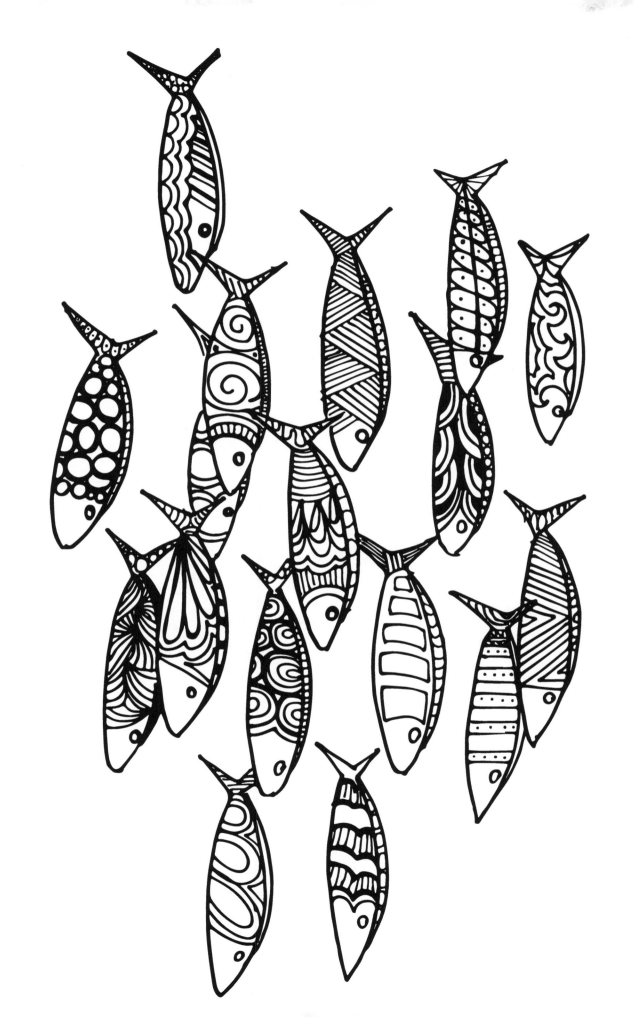

About the Artists

Daniela Licalzi Carolina Licalzi

Raised in Puerto Rico, Daniela and Carolina now live and pursue their creative passions

Read their full stories at:
www.bluestarcoloring.com/daniela
www.bluestarcoloring.com/carolina

READY FOR THE NEXT ONE?

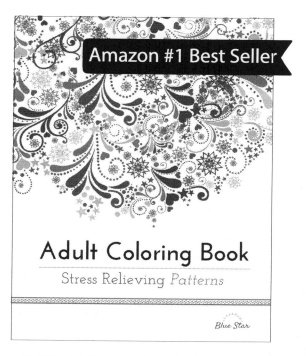

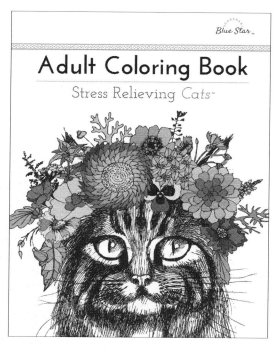

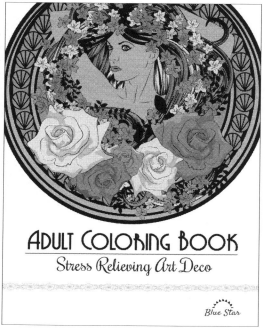

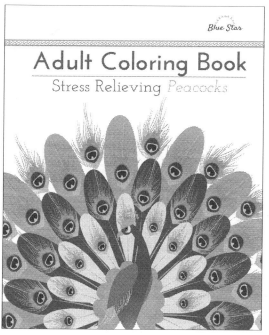

Look for the *Blue Star*

bluestarcoloring.com

70

43108595R00041

Made in the USA
Lexington, KY
17 July 2015